# ANSEL ADAMS
## Singular Images

# ANSEL ADAMS
## Singular Images

A Collection of Polaroid Land Photographs

Text by Edwin Land, David H. McAlpin

Jon Holmes, and Ansel Adams

**NEW YORK GRAPHIC SOCIETY**
Boston

International Standard Book Number 0-8212-0728-8

Library of Congress Catalog Card Number 73-93872

Third printing 1979

Printed in the U.S.A.

New York Graphic Society books are published by Little,
Brown and Company. Published simultaneously in Canada
by Little, Brown and Company (Canada) Limited.

I am deeply indebted to David McAlpin for his encouragement and generosity of thought, spirit and deed over many decades. We are all indebted to him for his great contributions to photography as a creative art.

The exhibit at the Metropolitan Museum of Art came about because of his imaginative efforts. I wish to express my deepest appreciation to him and also to the staff of the Department of Prints and Photographs of the Museum.

And my sincere thanks to Polaroid Corporation for their continued cooperation.

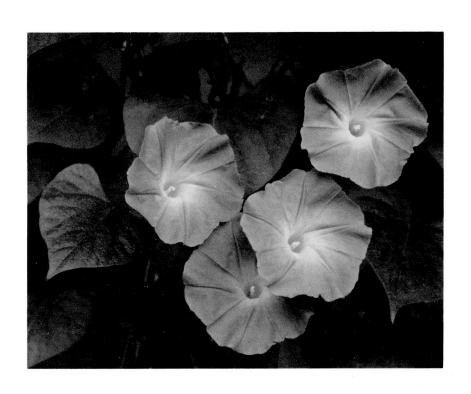

# PRIVATE RUMINATIONS ON LOOKING AT ANSEL ADAMS' PHOTOGRAPHS

*Edwin Land*

I suppose I have shared a provincial notion that delineative painting as it developed after Giotto is a close description of reality and that abstraction as it evolved over the centuries is more of a departure from external reality than the art which preceeded it. Photography with its easy synthesis of structured perspective was automatically cast in the role of the ultimate in delineative art, and came to be rejected as an esthetic medium except for its peculiar power in the evocation of poignancy. Thus the "hardest" and coldest of media became dedicated to the softest of purposes, and there stands no photographer, however great, who did not in spite of his best intentions lend his talent in some degree to romanticization, except one — Ansel Adams.

The seductress of all artists is sentimentality, and photography, born in the age of romanticism of empire and expansionism of industry, became the high art of recording with unwitting nostalgia the world in transition to new ideals and fresh illusions. Preoccupied with this task of recording, photography did not become a high art.

As I become more sophisticated about cognition and perception, I realize that photography and all delineative media can only appear to delineate; that the most abstract of concepts is the concept that any medium can be other than abstract. I

wonder if this is because the referenda for reality may well be cortical imprints individually acquired by each of us in an individual way, and because these personalized imprints do not respond to the superficiality of apparently precise delineation. The great artist takes us along the stepping stones of our past, those personalized imprints, on to a new and continuing pathway of his own. Stone by stone, he must extend our individual pathways, referring as he goes along to the old cortical imprints while adding his new ones.

Adams realized that even the most precisely representational photograph is so far removed from external reality that he was free to use such photography as a point of departure for his own kind of abstraction. That Adams has chosen what appears to be the most representational of media and subjects most prone to be represented, that he has chosen these to be the basis of his most abstract perceptions, is the first essential step in his genius. The challenge of making a nonsentimental statement about a grand insight into the abstract is multiplied a thousandfold when the components of the subject have names and reminiscences to characterize them — tree and twig, brook and boulder — components assembled furthermore not as accidents, but in their natural habitats, as ordinary, "beautiful" arrangements. The greater the photographic skill brought to bear, the more elegant the technology employed, the more serious the threat to the artist who would lead us step-by-step in his own direction. For, as compared with the forms in ordinary abstract art, the direct derivatives from reality are distractions of deadly power.

Thus the challenge which Adams undertook to meet was to show that these meticulously beautiful photographs, these instruments of distraction, could be directed by him towards unified new insights. He demonstrates that there is no greater esthetic power than the conversion of the familiar into the unbelievably new.

# STATEMENT *by Ansel Adams*

Photography, as a powerful medium of expression and communication, offers an infinite variety of perception, interpretation and execution. Since the advent of the daguerreotype in 1839, an ever-expanding facility of equipment, materials, functions and objectives has brought photography to the fore in practically every domain of human endeavor. The single informative or creative image, the cinema, television, the ever-growing applications of color, the new technical processes (such as holography) and, of course, the Polaroid Land systems — all represent an extraordinary achievement within only 135 years.

The exhibit at the Metropolitan Museum of Art, in 1974, takes place 38 years after my showing at An American Place, in New York City, under the aegis of Alfred Stieglitz. While photographs from the early 1930s are included, the exhibit is not intended as a "retrospective," but as a selected group of creative observations spanning more than fifty years with the camera. My life in photography has been extremely varied; I have worked as a professional-commercial photographer, doing medicals, "nut and bolts," catalogs, advertisements, journalistic projects and pictures of people. My dominating interest, however, has been what is loosely called "creative" work — with emphasis on the natural scene. Add to this a considerable amount of teaching, lecturing and writing (and a compulsive resistance to keeping records of places and dates) and it is obvious that only a trained biographer could create order out of such chaos. The artist should not try to describe himself or his work! To young photographers, I say: "Do not be afraid of the practical and mundane aspects of the medium; they will strengthen your technique and discipline and give you a broader perspective of the world we live in." Having been trained as a musician, I am very much aware of the inevitability of the arduous hours devoted to "practice" so that the expressive intention and thrust will be liberated from the restraints of technical inadequacies.

I first met Edwin Land in 1948 and was immediately aware of the vast potentials of his "one-step" silver-diffusion process which is now a most important branch of the great tree of photography. My interest in the Polaroid Land process is primarily esthetic although I have been deeply concerned with the techniques which make the esthetic realizations possible. I am pleased to have the opportunity this exhibit affords to display work with the Polaroid Land process. The collection of original prints includes images made with a variety of materials and equipment — from the first roll-film to the recent pack cameras, and the 4x5 materials used with standard press or view cameras. In a small way, these prints cover twenty years of the development of the process. At various stages the images would show warm, neutral or cool values of tone; the spectator will see the original print qualities and tonal values as there has been little, if any, perceptible change in the prints over the years. In the exhibit, there will also be found enlarged images from the Types 55 P/N

and 105 P/N negatives. This monograph reproduces all of the Polaroid Land photographs on display. The original prints are reproduced in actual size, but the enlarged images are presented in varying scale.

I find it impossible to "verbalize" on the expressive content of the photograph — mine, or anyone else's. If the image cannot stand on its own, so to speak, no patina of words will enhance it. Photography has been cursed with "explanation" more than has any other art form. I am a firm believer in the Stieglitz concept of the Equivalent: for the artist, the photograph represents something perceived and deeply felt — the *equivalent* of an emotional or esthetic experience. The spectator may accept, reject or be stimulated to construct an experience of his own when viewing a work of art. His reactions should not be regimented by the imposition of literary titles or mystical benedictions. If there is ever a situation where the individual can truly commune with himself it is in the presence of creative art.

People in general rarely have a grasp of the complexities involved in the practical and useful expressions our technologies permit. We are instructed to follow some simple sequential procedures and seldom realize that modern technology requires intention, comprehension and discipline to obtain optimum results with any medium, especially one relating to the creative arts. In conventional photography, we have controls of exposure and development of the negative and an even wider range of control in the printing and enlarging processes. The results, however, depend upon *visualization* before exposure (intuitive or cogent) — some anticipation of the final image in terms of scale, texture, luminosity and tone, to say nothing of the management of the external shapes into the forms presented within the picture area. In positive color photography and in the Polaroid Land process, we must "see" with great selectivity — not only in relation to the composition, but to the values and contrast of the subject and the limitations of the medium used. Once we become facile with a medium, we can achieve highly-successful images with a minimum of controls. It is clear that photography is a language with which a knowledgeable photographer can produce records, reports, essays, diary-entries — even poetry!

It is gratifying to me that so many young men and women are deeply involved in the many aspects of the medium of photography. They are exploring new worlds, realizing new visions and experiencing new dreams. For me — and for others of my period — it would be presumptuous to attempt any mere imitation of the young perceptions and objectives. We must encourage rather than scorn the sincere explorations at the edge of the present and well into the future. At the close of my 1936 exhibit, I recall asking Alfred Stieglitz what he thought I should attempt to do and which directions of photography he thought were important. He replied: "I don't care what you do, just that you go beyond me!" I hold no thought of having "gone beyond" Stieglitz, but rather that I was encouraged to follow my own directions. I do what I can and must in my own fields, yet confess to a gentle envy of the young people who are at the threshold of great and fresh experiences in new domains of the visual image. I can see no limits to the potentials of the great communicative art-form of our age — Photography.                    *March, 1974*

# ANSEL ADAMS, AMERICAN PHOTOGRAPHER

*Jon Holmes*

Ansel Adams wrote, in 1938: "What I will be at sixty, seventy and eighty remains to be seen. Probably I will be a photographer." With this new show and monograph, he celebrates passing the second of those high-water marks — very much a photographer.

But there is much more to the story than that. Ansel Adams is one of America's most popular visual artists, with almost three-score books in print, six publicly-subscribed portfolios, three Guggenheim Fellowships and exhibitions in virtually every major American art museum. *TIME* magazine, the *Today Show* and appearances in television commercials — an accolade usually reserved for movie stars and professional sports figures — have brought him and his work into millions of American homes.

That popular acclaim is, in part, the result of Adams' activities in conservation and the environment, for he has long been associated with the Sierra Club, Yosemite and the National Park Service. Another basic reason for his popularity both as an artist and environmentalist must stem from the medium he employs. Photography is a grass-roots form of esthetic expression and emotional recording for Americans, who produced an average of 84 pictures per household in 1972. That amounts to an amazing 5.6 billion images in a single year.

And there is a third, more subtle, psychological factor at work in Adams' choice of subject matter. The Adams photographs with which people are most familiar show the sweep and majesty of the Western mountains, devoid of any sign of humanity. They fulfill a need for solitude and serenity while appealing to the fundamental wanderlust which each year drives millions of vacationing Americans into our remaining wilderness areas.

There is something in Adams' spirit reminiscent of pioneer Western photographers such as William Henry Jackson, whose work was responsible for the establishment

of Yellowstone as the first national park, and Timothy O'Sullivan, whose work
we know largely through Adams' efforts with The Museum of Modern Art. Adams' subject
matter — awesome Nature — is the same. Through the years, he has certainly put in
enough miles leading mules laden with his equipment over the Sierras to equal the
stamina and endurance of the other two. His tools are better than were theirs, but as both
recorder and printmaker, his craft is far greater.

Adams, in addition, has that quality which, in 1932, his close friend, Edward Weston,
described in a letter to him as "seeing plus." Weston wrote: "Photography as a
creative expression. . . must be seeing plus; seeing alone would mean factual recording —
the illustrator of catalogues does that. The 'plus' is the basis of all arguments on 'what is
art.' "

The "plus" in Adams' work takes the form of flawless composition, precision in
recording the most minute detail and an almost fanatical devotion to tonal
renditions of colored subjects in monochromatic prints. That "plus" quality, so hard to
define, also covers the genius which allows him a sense of astonishment and rapture
in the beauty around him. His craft allows him to convey that exact sense which
caused him to photograph the scene in the first place.

Adams stands as his own tradition, with more than a half-century of camera work
behind him. He is the man who taught us to measure photographs by the square
foot and subject matter by the mile. Combining proto-environmentalism with
his natural curiosity for the technical, he produced his first photomurals for the Yosemite
Park exhibit at the 1935 San Diego Fair. In Washington the next year, as a representative
of the Sierra Club attempting to establish another national park in the Kings River
Sierra, his sense of scale so impressed the Secretary of the Interior that he was asked to
produce a series of murals for government office buildings. (The Kings Canyon
National Park, by the way, was created by Congress in 1940, following publication of his
book of photographs of the area, *Sierra Nevada: The John Muir Trail.*)

The point of this is that it is damned unusual to see Ansel Adams photographs the
size of the original Polaroid prints on display in this 1974 exhibition. Unusual, that

is, except on the walls of the artist's home or in his publications; but most, because of their nature as unique, one-of-a-kind images, have been carefully hung or filed away for just such a project as this exhibit.

These are the pearls of great price — as valued as original negatives. Some date to 1954, when Adams began experimenting with this new technique. Those first trials caused him to write in the *Basic Photo Series:*

> "The recent advances in the Polaroid Land process open new vistas for functional and expressive photography. Not only does the process serve to 'check' lighting, exposure and composition in conventional photography, but — and more important — it is itself a new creative medium."

Again, almost a decade later, in 1963, he wrote in his *Polaroid Manual:*

> "It is unfortunate that so many photographers have thought of the Land camera as a 'toy', a casual device for 'fun' pictures, or, at best, a 'gadget to make record pictures!' . . . The process has revolutionized the art and craft of photography — and is still barely across the threshold of development."

Beyond the respect which Adams has for his subjects, he has a deep respect for the materials with which he works. And he is uncompromising about quality — both in the image and in the print.

In one sense, Adams has molded his esthetic awareness to these materials. His original Polaroid prints are exquisitely-constructed miniatures, with their subjects in a proper scale with the size of the finished image. These are portraits, details from nature and scenics which precisely fit the image format. No attempt was made to squeeze the Sierras into a 4 x 5, or to engrave Yosemite on the head of a pin. Each plate in this series is reproduced exactly the size of the final photograph.

One comment could be made about the effect of the medium upon the artist: the Polaroid materials caused him to move in on the subject — to get closer and perhaps even more involved with that which he was recording. Quite possibly this is

the result of the format restrictions already mentioned. More likely, however, it reflects that unique quality of the materials themselves — the instant feedback, the immediate return on an artistic investment. A great number of artists, other than Adams, working in this original print medium are portraitists who depend on the development of an intimacy, through photography, with their subjects. Adams' photographs display this same intimacy whether the subject is a person, a detail from a tombstone or a row of wooden shingles.

His portraits really stand apart. There is one of his wife, Virginia, which sparkles like the dew on morning grass. Adams' portraits of other photographers are among his finest work. The much-photographed Margaret Bourke-White is transformed before Adams' lens from combat photographer to creature of incredible warmth and sensitivity. These are tactile images in which the viewer can reach into the frame and touch the subject.

On the other hand, Adams' enlargements from Polaroid negative materials reflect his realization that they would be viewed in their finished form as enlargements, where the viewing distance changes and the sense of proportion is altered drastically. These images deal with larger subjects, treated on a grander scale. Groves, rushing water, the sea, and El Capitan all require this larger perspective. There is even a bit of whimsey in a wide-angle photograph of a fishing boat, head-on, enlarged to imposing and even absurd dimensions.

More impressive still are the abstractions — rocks and limpets, light refracting on a tidal river, the pattern of cypresses against the sky. The images are fully-realized creations from the natural scene, rather than recordings.

Ansel Adams, at seventy-two, is one of the strongest of photographers. He has had quite a bit of practice over the past 50-odd years. And Adams practices photography with the same intensity he must have worked with at the piano when, in his teens and twenties, there was every likelihood that he would spend his artistic life in the recital hall rather than the field and darkroom. Fortunately, he chose the visual arts.

Witness this show and the photographs involved. Not bad for a piano player. Not bad at all!

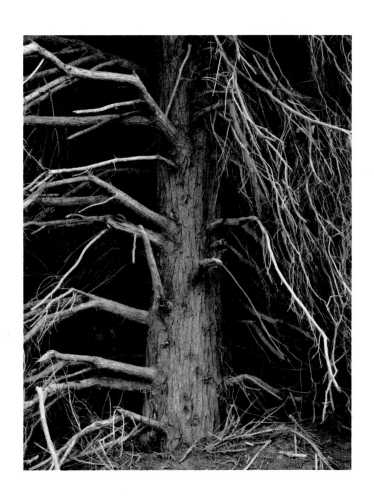

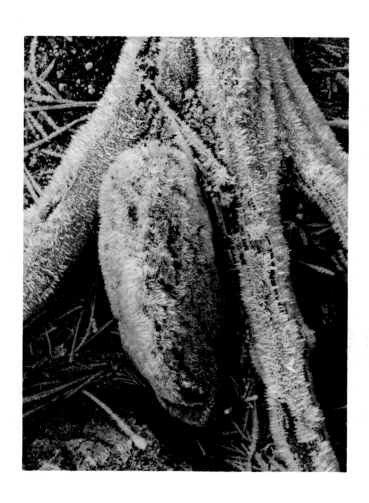

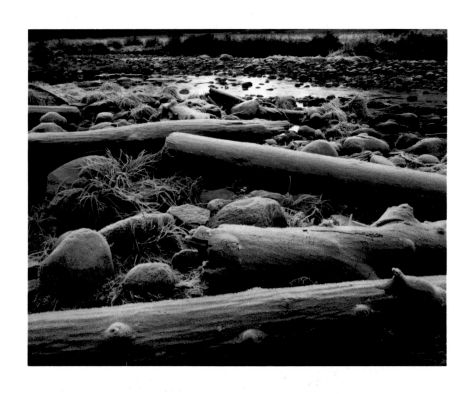

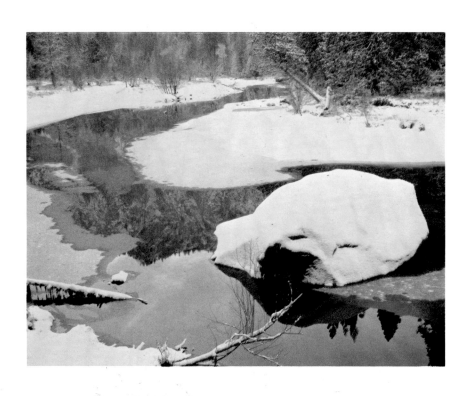

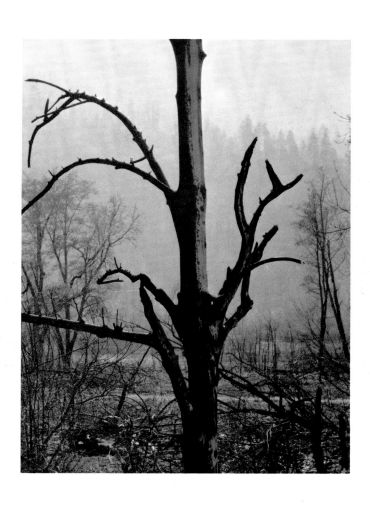

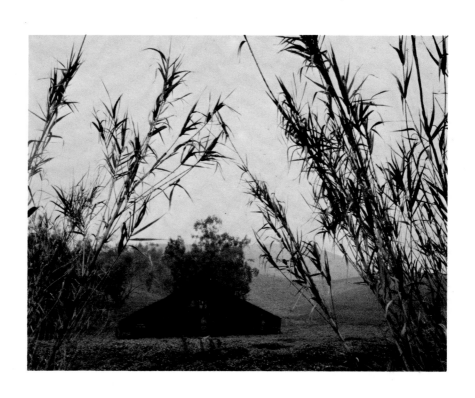

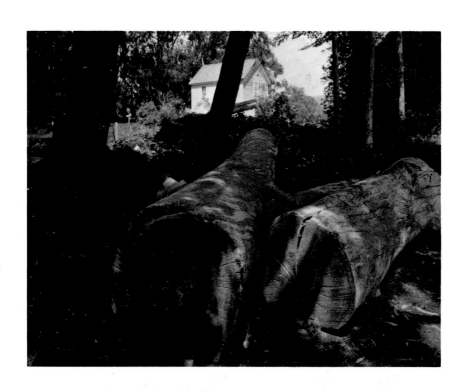

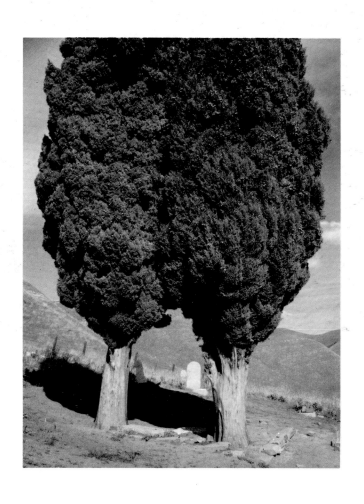

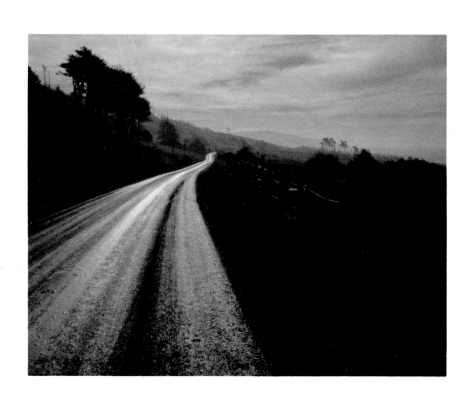

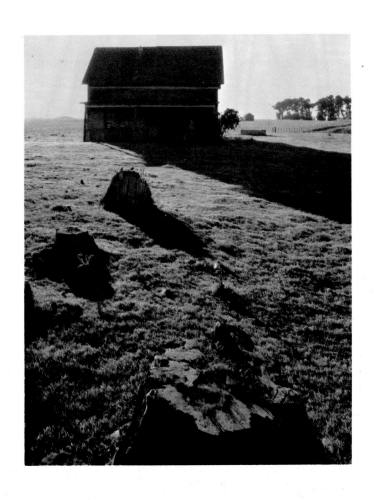

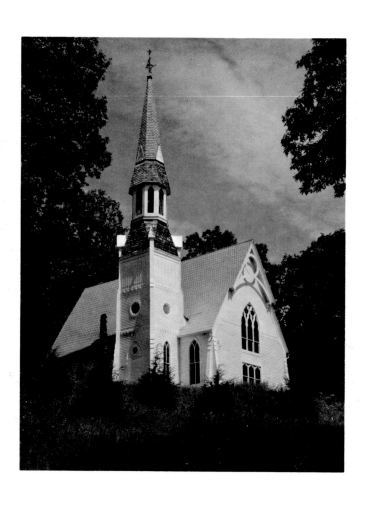

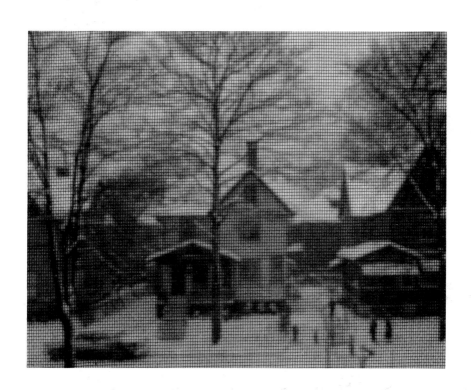

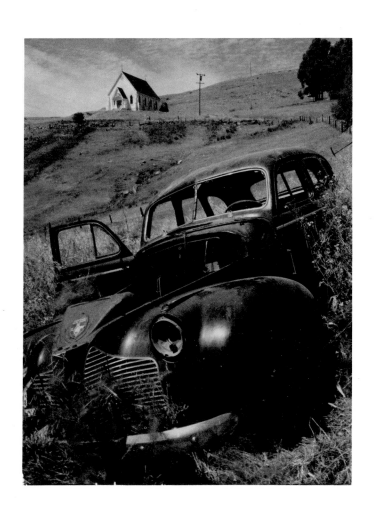

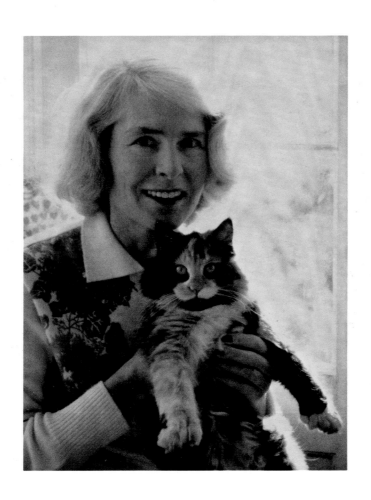

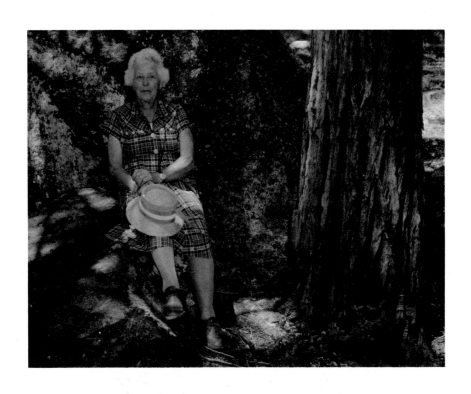

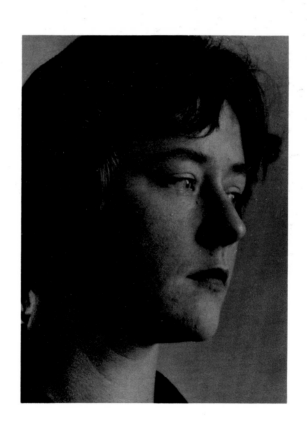

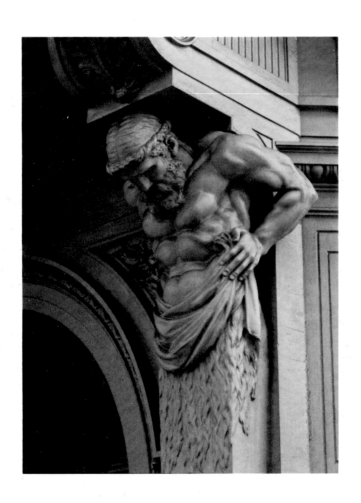

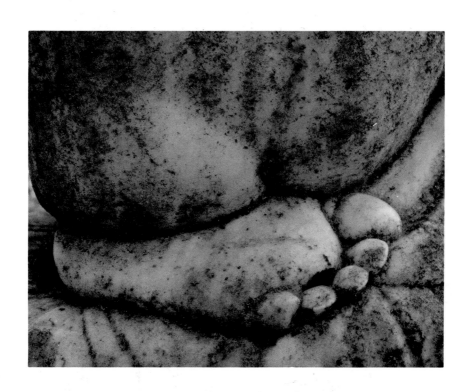

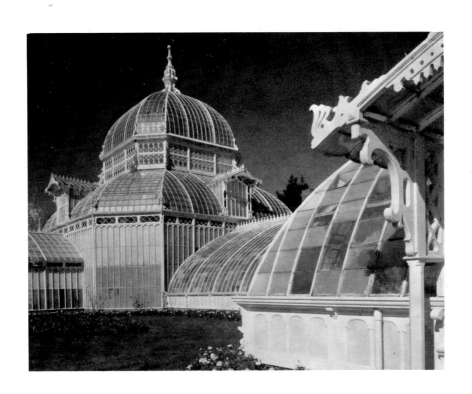

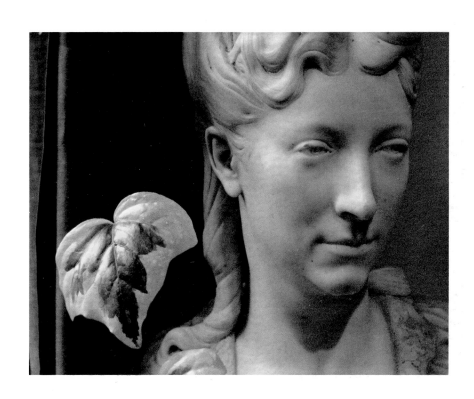

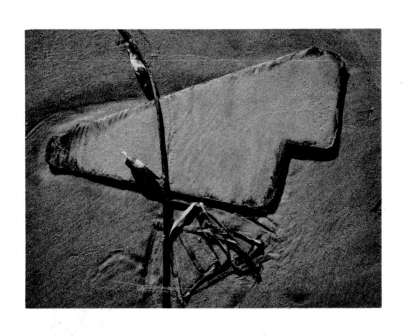

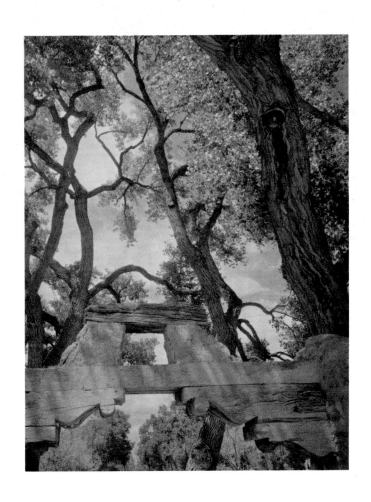

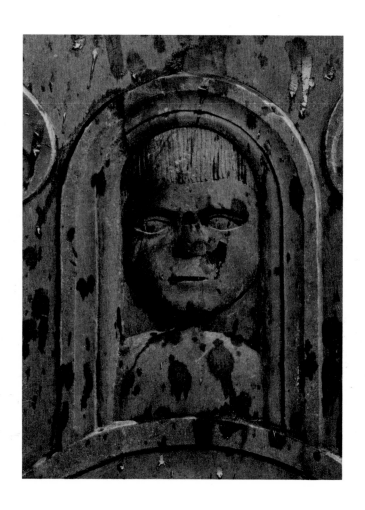

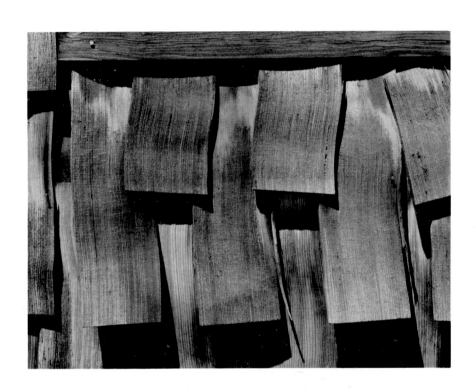

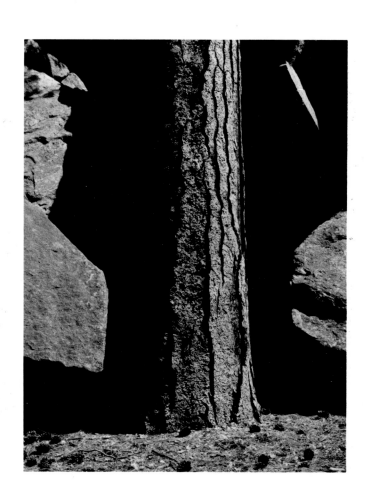

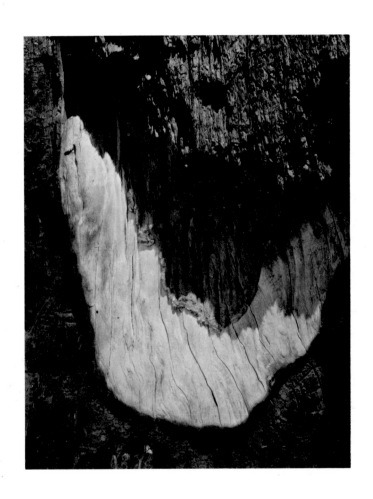

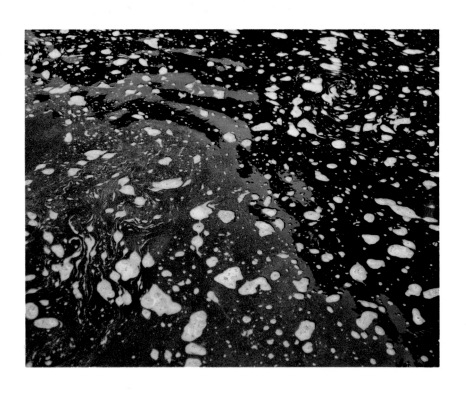

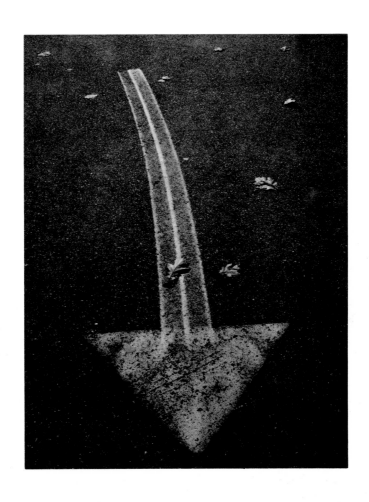

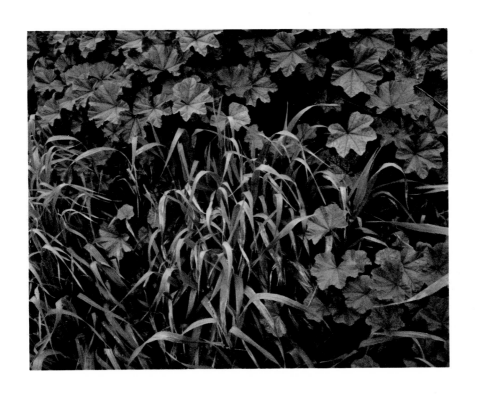

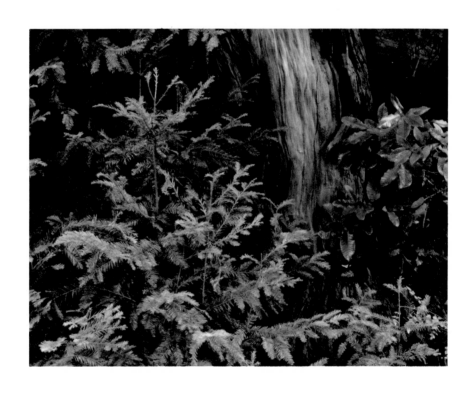

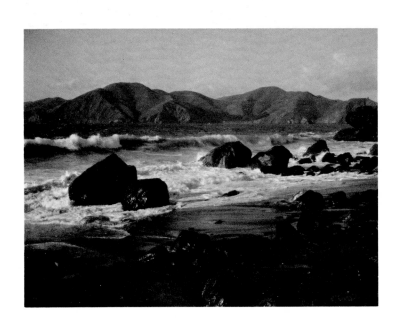

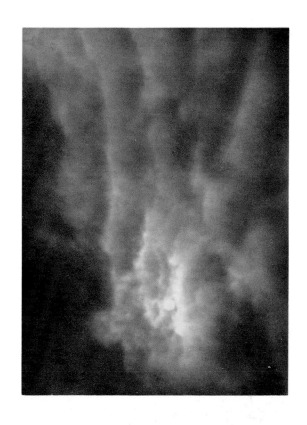

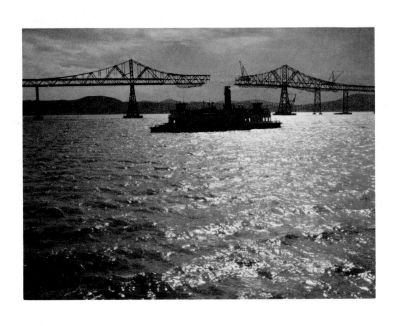

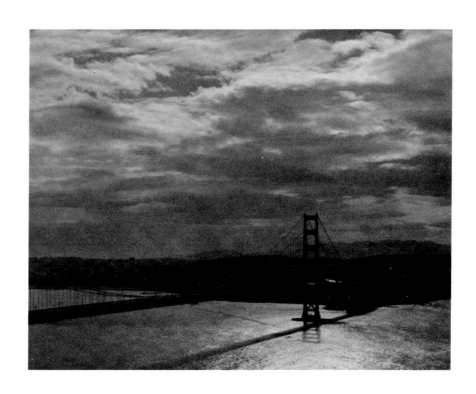

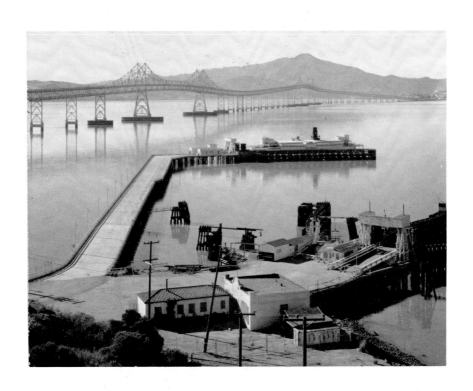

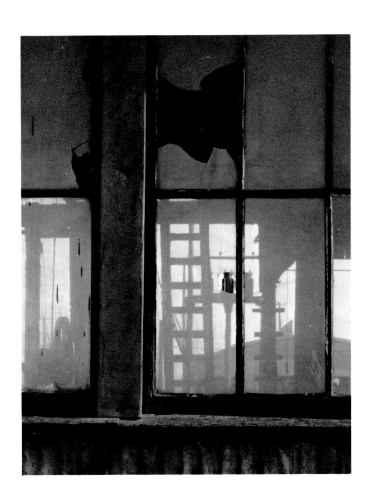

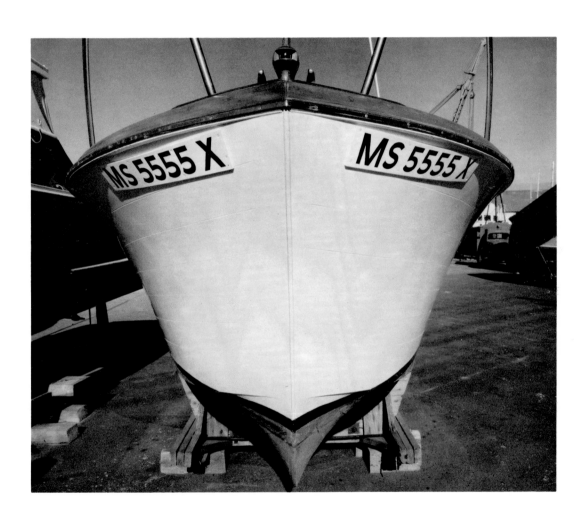

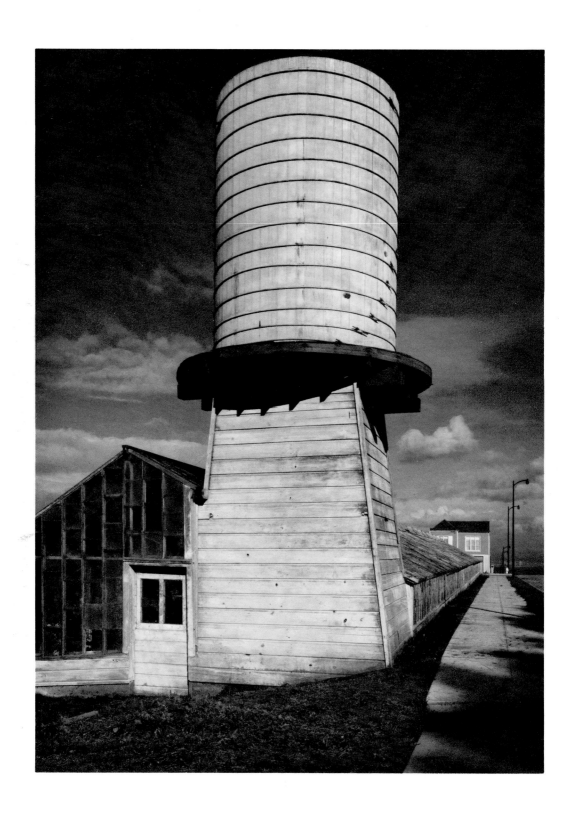

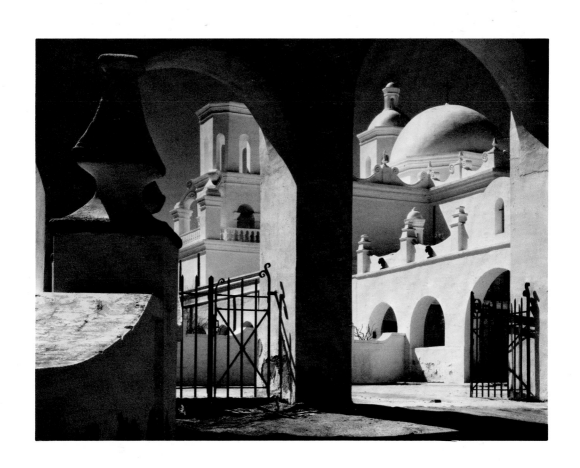

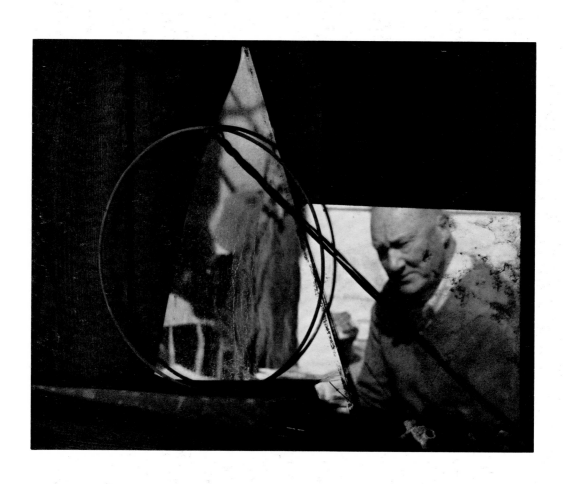

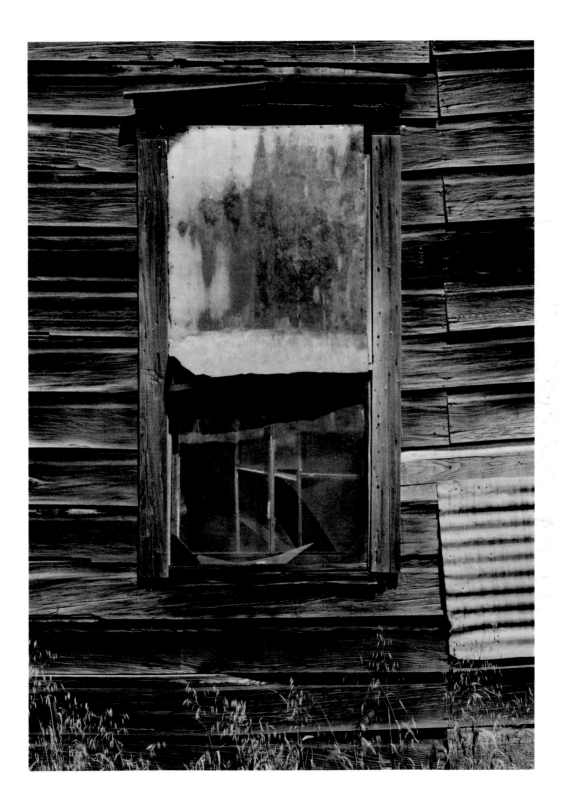

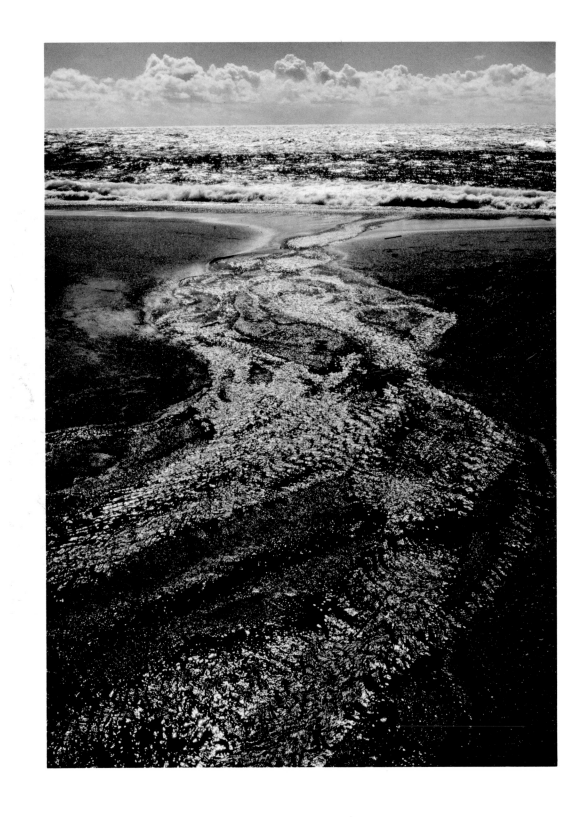

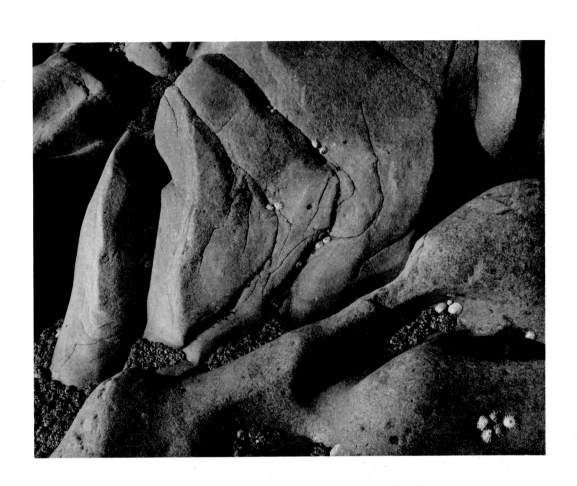

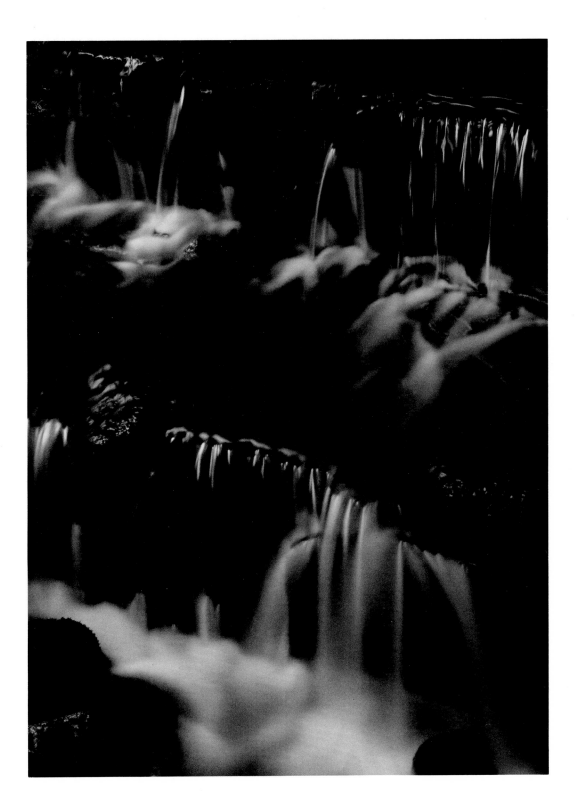

48

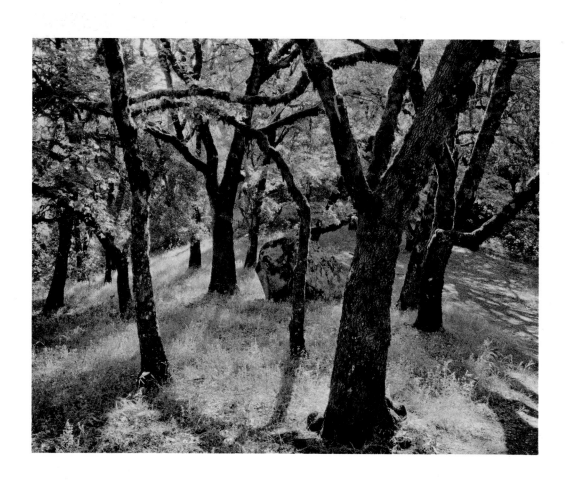

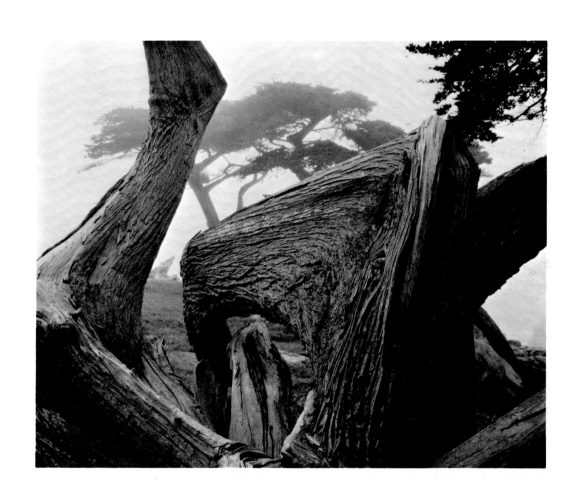

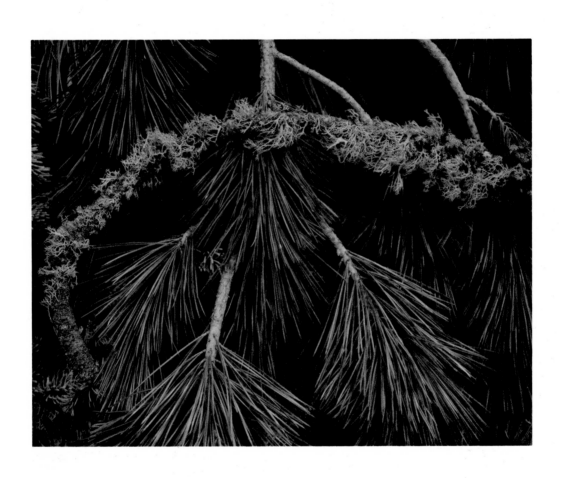

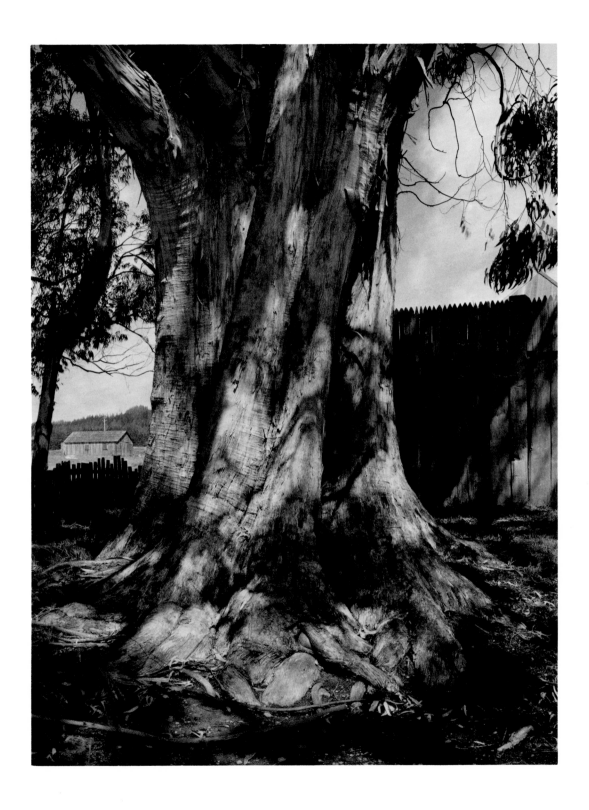

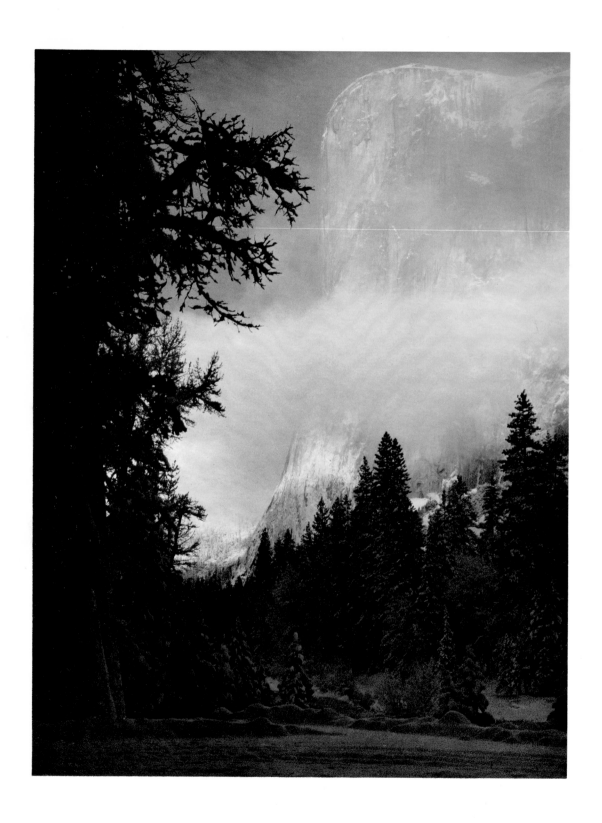

## LIST OF PLATES

Plates 1 through 40 are reproduced from original Polaroid Land prints of various types. Remaining plates are reproduced from enlargements made from Polaroid Type 55 positive/negative Land film with the exception of plate 45 which is an enlargement from a Polaroid Type 105 positive/negative Land film.

# PHOTOGRAPHIC EXPERIENCES WITH ANSEL ADAMS

*David Hunter McAlpin*

Ansel Adams is not only an outstanding photographer, but also an extremely well-rounded humanist. Early training as a pianist gave him discipline, sensitivity and balance. When he took up photography seriously and professionally, those qualities were reflected in his sense of composition and tonality, his esthetics of vision and appreciation of the technology of the photographic processes. He has made his experience available to other photographers through the series of *Basic Photo Books* and other books of technical and creative character.

## THE 1936 EXHIBITION AT ALFRED STIEGLITZ' "AN AMERICAN PLACE"

Adams is a perfectionist at heart. In preparing for this New York exhibit, he recognized its importance and devoted himself to the making of prints of superior quality. Stieglitz was a great stimulating force and Adams was one of the very few photographers exhibited at the Place. I first met Ansel in 1936, and through the years accompanied him on excursions to a number of interesting areas.

## THE GHOST RANCH NEAR ABIQUIU, NEW MEXICO — ON TO ARIZONA AND NEW MEXICO WITH GEORGIA O'KEEFFE, SEPTEMBER 1937

Based at the Ghost Ranch, we spent ten days touring the area encompassed in the original Spanish Piedra Lumbre Land Grant. It is a large and varied complex of hills, bluffs, plains and the beautiful Chama River Valley and includes several old rural villages and Penetente Moradas. One day we were driving on a country road at a good clip, Adams at the wheel. Suddenly he braked the car to a standstill, then backed up for a considerable distance. While driving, he had glimpsed a picture out of the corner of his eye. His mind computed the possibilities and, apparently, the image was satisfactory.

On one expedition we were joined by Georgia O'Keeffe with her roadster, and Orville Cox with a station wagon filled with supplies, camping gear and four congenial companions. Orville was a senior wrangler at the Ghost Ranch; he had grown up in the area, knew many Indians and spoke several of their dialects. He had served for archaeological expeditions and was with the American Museum of Natural History Expedition at the excavation of the Chettro Kettle ruins. His experience and knowledge provided us with much excitement and an awareness of the qualities of the wonderful lands we traversed.

We reached Laguna Pueblo at sunrise one bright morning. A drowsy mongrel was standing in the roadway, giving a fine accent to the otherwise static Pueblo at that early time of day. Another well-known photograph was promptly made.

A few days later, we arrived at "Cosy" McSparron's Thunderbird Trading Post at the mouth of the Canyon de Chelly. The Post was located on a level area, above the usually dry stream bed; while we were in Cosy's warehouse selecting fine Navajo blankets, there was a torrential downpour, flooding the area and turning the floor of the canyon into quicksand. Later, when the sun appeared, we walked along the

top of the cliff on the south side of the canyon. A mile or so east, the Canyon de Chelly joins with the Canyon del Muerto, makes a big bend and widens. This provides a good place for fording the stream, by then a swiftly-flowing torrent due to the recent storm. Just as we came upon the scene, a band of Navajo Indians started to cross on their ponies, riding in single file, far below us. This was a memorable experience; Adams often returned to this magical place over the years.

Eventually, we broke camp and proceeded to Colorado, where we continued along the famous "Million Dollar Highway." Despite its Chamber of Commerce name, it traverses a beautiful and spectacular region. We spent a night at Silverton, once a prosperous silver-mining town. Strolling among the abandoned mines, Adams secured one of his best early images. It was of two rusted strips of iron which lay crossed over the bright texture of a slag heap. The late afternoon light was just right for this particular situation.

## CAPE COD IN SPRINGTIME, 1937

The weather was balmy, shadblow in bloom everywhere. Adams found many subjects: saltbox houses, several fine barns, an old windmill and gravestones in ancient cemeteries. His best photograph in the region is of a white barn sternly rising beyond a picket fence. Adams admits it may recall Paul Strand's "Picket Fence," but it was visualized on its own merits. It has appeared in the Encyclopedia Britannica and many exhibits. The photographer seldom, if ever, anticipates the ultimate disposition of his work!

## CRUISE DOWN THE INLAND WATERWAY FROM NORFOLK TO SAVANNAH, NOVEMBER 1937

We joined the Alden schooner, "Billy Bones III," as soon as the hurricane season was past. We sailed through the Dismal Swamp Canal, across Pamlico and Albemarle Sounds, down the Cape Fear River and on to Charleston, South Carolina. Anchor was weighed each morning and, after the day's run, we went ashore to walk through the villages which provided many new and attractive images. When our cruise time ran out, we were loath to leave the good ship and its jolly company. This part of the country is very subtle and difficult for photography; Adams has always hoped to return and explore it in depth.

## PACK TRIP IN YOSEMITE NATIONAL PARK, SEPTEMBER, 1938

Adams had been urging such a trip for several years; the High Country of the Park was little known and is exceptionally beautiful. After a busy summer, we made a rendezvous with him, O'Keeffe and four other friends at Carmel, where we spent the night (Adams then lived in San Francisco and Yosemite Valley). We enjoyed a delightful evening with Edward and Charis Weston at their home on Wildcat Hill, experiencing friendly warmth, simple hospitality and the 26 domestic cats which Edward both supported and endured. The next day we crossed Pacheco Pass and drove eastward through the San Joaquin Valley to Merced; on through Mariposa and the Merced River Canyon and into the Yosemite Valley. There, the head wrangler outfitted us with riding and pack horses, equipment and supplies

for 17 days in the High Country. A gentle white horse carried two panniers in which Adams' cameras, tripod and film were carefully packed. Virginia Adams remained in the valley to care for the studio — a fledgling enterprise at the time. Virginia had inherited the studio from her father Harry C. Best, an artist of the Hudson River School, who had painted in the Valley for many years. Best's Studio sold photographic prints, sophisticated Southwest Indian jewelry and artifacts etc., and in 1947, began the annual Photography Workshops. Recently, the studio was renamed the Ansel Adams Gallery and is now under the direction of the Adams' son, Dr. Michael Adams, and his wife Jeanne.

The next morning, we ascended the steep Snow Creek Trail at the head of the Valley, crossed Mount Watkins Ridge, passed beautiful Tenaya Lake and arrived at Tuolumne Meadows, our first camp. We then traveled south, entering the Cathedral Range, and camped at the foot of Cathedral Peak where Adams initiated us in rudimentary techniques of rock climbing. An ardent climber since he was eighteen, he led us along a sharp ridge to the highest crag. In those days it was really "scrambling," and we took many grave chances without realizing it.

Our principal camp was in the valley of the Lyell Fork of the Merced River, looking across a quiet pool to the summits of Rodgers and Electra Peaks. Adams made a fine "decorative" picture looking straight down into the pool with pine needles floating on its surface. My wife and I were greatly pleased with a photographic screen, composed of three sections, five-feet high, made from this 4x5-inch negative. This was one of his first experiments in large fine-print making.

We had many great experiences on this excursion among the sculptured mountains of the Sierra Nevada. At the close of the trip, we passed Merced Lake and traveled down the Merced Trail, past Nevada and Vernal Falls to the relatively "civilized" floor of Yosemite Valley.

An album of photographs, recording our High Sierra pack trip, arrived that following Christmas as a souvenir for the members of the expedition. Adams, a dedicated conservationist, has been a member of the Sierra Club and served on its Board of Directors for more than thirty years. He now likes to be called an "environmentalist" and is very much aware of the great problems facing all of us through our misuse of natural resources. He believes photography is a great instrument for education and demonstration in this tragic situation.

Adams' splendid book of mountain photographs, *Sierra Nevada: The John Muir Trail*, was commissioned by the late Walter Starr in memory of his son, Walter Starr, Jr., a noted climber and explorer of the Sierra Nevada. In general, this book relates to the entire crest traversed by the John Muir Trail (leading from Yosemite to Mount Whitney in the southern part of the Sierra).

## AT THE MUSEUM OF MODERN ART IN NEW YORK, 1939-1942

An increasing interest in photography was in evidence at The Museum of Modern Art in the late 1930s. Alfred Barr (then Director) and Beaumont Newhall (then Librarian) were both keenly interested in historical and current examples of photography and were busy organizing a major exhibition to commemorate the

one-hundreth anniversary of the art. An outstanding group of 19th-century photographs were borrowed from museums and private collections in Europe and the United States. Newhall wrote his *Short History of Photography* to accompany this exhibition. This book, later expanded and *Short* dropped from the title, is now recognized as the finest work in its field.

Because of the widespread interest aroused by this Centennial Exhibition, The Museum of Modern Art trustees decided to launch the first Department of Photography of any museum in the country. In 1940, a Photography Committee was formed: Newhall became the department head (and its curator) and Adams served as vice-chairman and technical advisor. Over the years, this department has had a gratifying growth and a profound effect on the development of creative photography throughout the world.

For several years, Adams had been formulating and practicing his Zone System of exposure and development for black-and-white negatives. It is, in terms of visualization, also quite useful in color photography. This is not his "invention," but a practical and useful interpretation of sensitometry. Adams lectured at the museum on the Zone System and his personal concepts of photography as an art form.

## NATIONAL PARKS AND MONUMENTS

In 1940, Secretary Ickes, of the Department of the Interior, invited Adams to engage in a "photomural" project relating to all the activities of the Department — Parks, Indians, Mines, Reclamation, etc. This large project never came to pass because of the intervention of World War II. Nevertheless, he made a start with the National Parks and, after the war, was granted a Guggenheim Fellowship to continue his work in the National Parks and Monuments. The result from this grant was *Portfolio II,* and a handsomely-reproduced book, *My Camera in the National Parks.*

## SANTA FE, JANUARY, 1942

One morning while my wife and I were visiting in Sante Fe, the phone rang; Adams was at the La Fonda Hotel. He urged us to join him and go to the Indian dances that afternoon at San Ildefonso Pueblo, north of the city. We arrived just in time to watch the performers coming out of the rooms where they had been dressed and painted for the ceremonial dance. They descended the open steps to the plaza in single file in their full regalia. The Pueblo dances are always impressive. In no time at all, Adams had exposed all his 4x5 film. For several hours he photographed the dances with his 35mm camera. As he once said to me, "I preach thoughtful work, but at times I can be a real shutter-bug." This approach contrasts markedly with his usual attitude of working and with that of other well-known photographers such as Charles Sheeler and Edward Weston, for whom a full day's work with a view camera consisted in making only a few negatives. I have seen Sheeler set up his camera on the porch of a cabin by an Adirondack Lake and patiently watch for something to happen — for a canoe or sailboat to pass close by, unusual cloud effects or the late afternoon sun casting long shadows. However, in spite of an occasional "machine-gun" use of the 35mm camera, Adams is very

critical and retains only the negatives which are appropriately composed and exposed, then further refines his selections in the darkroom. But his work always gets ahead of him and a large section of it has yet to be printed.

## FRIENDS OF PHOTOGRAPHY — CARMEL, 1967

In the early 1930s, Adams was instrumental in founding Group F/64 and has had a continuing interest in promoting the medium in its creative aspects. With a group of able and enthusiastic photographers, Adams assisted in the organization of the Friends of Photography, a non-profit educational enterprise. With the Friends of Photography, a center was provided for a variety of related activities. Exhibitions are continually on view at the Gallery in the Sunset Cultural Center. Two fine portfolios have been published. Workshops and seminars are held with increasing frequency and often involve the other arts.

## EXHIBIT AT THE METROPOLITAN MUSEUM OF ART, 1974

When Edwin Land introduced the revolutionary concept of "one-step" photography, Adams was intrigued and began to experiment with the Polaroid Land cameras and films. My wife and I were in San Francisco in the late 1950s and we found that Adams had mounted a splendid exhibit of his own Polaroid Land prints. This was the first time I had seen such a collection; the subject matter was varied and the tonalities most subtle.

I am pleased that another superb collection of his Polaroid Land prints are included in this exhibit, covering work with that medium from 1954 to the present. The exhibit as a whole presents work accomplished over a half-century including *Portfolios V* and *VI* in entirety, as well as excerpts from previous Portfolios and a selection of prints from early and recent negatives. A darkroom fire in Yosemite many years ago, destroyed over 5000 negatives. Fortunately, prints of some of those lost negatives are in the archives of the Art Museum of Princeton University.

Adams, at 72, says: "I am just starting to work!"

Edited and designed by Liliane De Cock
Typeset in Baskerville
Printed by Morgan Press, Dobbs Ferry, New York